W9-ANO-169

The Well-Bred CAT

The Well-Bred CAT

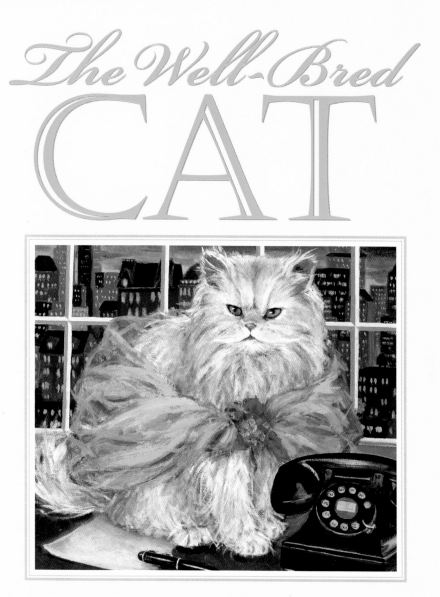

Lisa Zador's Folio of Fabulous Felines
Stories by James Waller

Stewart, Tabori & Chang
New York

Text copyright © 2002 by James Waller

Artwork copyright © 2002 by Lisa Zador

All rights reserved. No portion of this book may be reproduced, stored in a retrieval system, or transmitted in any form or by any means, mechanical, electronic, photocopying, recording, or otherwise, without written permission from the publisher.

Published by
Stewart, Tabori & Chang
A Company of La Martinière Groupe
115 West 18th Street
New York, NY 10011

Export Sales to all countries except Canada, France,
and French-speaking Switzerland:
Thames and Hudson Ltd.
181A High Holborn
London WC1V 7QX
England

Canadian Distribution:
Canadian Manda Group
One Atlantic Avenue, Suite 105
Toronto, Ontario M6K 3E7
Canada

ISBN: 1-58479-251-5

The text of this book was composed in Adobe Garamond.

Printed in Hong Kong

10 9 8 7 6 5 4 3 2 1

First Printing Designed by Jay Anning, Thumb Print

To
BOWSER AND BANJEE GIRL

PREFACE

LISA ZADOR INHABITS THE SAME WORLD AS THE REST OF US—a world where human beings and animals constantly interact: loving each other, offering selfless companionship, sometimes understanding each other very well (and sometimes decidedly not), and occasionally getting on one another's nerves like nobody's business. But Lisa's depictions of our four-legged friends also turn our own, familiar world squarely on its ear. In the bizarre parallel universe her pictures record, cats and human beings continue to relate—but now they do so as equals. The results are charming, hilarious, and maybe a bit unsettling.

Lisa's not the first animal painter to have dressed her subjects up in people's clothes or placed them in distinctly human settings. But she's taken this strange little genre to a much more interesting—and entertaining—level. The conception of each of her pictures—the content *and* the style—grows out of her response to the cat-sitter's own personality. (The cats she portrays are all real, live animals—some belonging to friends, others waiting for homes in a New York City animal shelter. The actual names of Lisa's models—and of their owners—appear at the end of this book.) Lisa's paintings aren't cartoons or mere "illustrations"; they're real *portraits*, often as revelatory of character as we expect pictures of people to be. Sure, some of the images are silly; but what's striking is that they're all so *good*.

For me, working with Lisa on this book has been an unmixed pleasure. Adopting the pose of art critic and (unrepentantly punning) raconteur, I've been as inspired by Lisa's pictures as she is by the animals she paints. It's been a pet project, and I can honestly say that there's nothing I'd rather have done than to be Lisa's cat's-paw. I hope you'll have just as much fun reading the stories that accompany the paintings as I've had writing them.

So, without further ado, let's step into the looking-glass world of "Zador" and her fabulous felines.

—JAMES WALLER

ZADOR'S WELL-BRED CATS

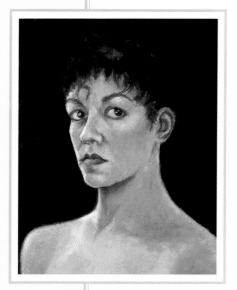

ANY CAT SCANNING THE ARTS OR SOCIETY PAGES will surely have noticed how frequently Lisa Zador's name pops up these days. She's forever being spotted dining in châteaux, cruising the Canaries aboard some tycoon-cat's boat, perched up close to the catwalk—right next to Miu Miu—at the Milan shows, dashing catty-corner from Bergdorf's to Tiffany's, or betting the kitty at some invitation-only poker tourney in Vegas. She has been fêted, celebrated, *lionized.*

Zador is, quite simply, the hottest cat portraitist around. She's definitely in the catbird seat, but the charmed life she now leads rests on some very hard-earned laurels. For years, fame played cat and mouse with her. After training at the École des Beaux-Arts, Zador tried her hand at various genres—landscape, still life, pajama-fabric design—but none really pleased her, and commissions were few and far between. "My career was really on the fritz," she recalls.

Then, a little sketch Zador made of one of her canine—that's right, *canine*—friends attracted the attention of a hot-dog art collector. With the imprimatur of that self-aggrandizing bitch, Zador gained entrée to the social world (and whirl) of dogdom's luminaries. They thought they had her all to themselves. They thought wrong.

With an audacity matching Dylan's when he picked up an electric guitar to perform "Leopard Skin Pillbox Hat" at that long-ago Newport Folk Festival, Zador decided to bust through the interspecies barrier. When London's National Portrait Gallery commissioned her to paint British math whiz Atticus (see page 10), she leapt the cat-dog divide. Yap yap yap yap yap, complained the jackals of the press, but Zador was having none of their bigotry. The truth is, she likes cats, too.

And the cats she paints adore *her*. They like the fact that she refuses to be categorized, artistically—instead experimenting with a kit bag of styles ranging from a subdued, Catlin-esque realism to an almost-feral expressionism. (To see what I mean, just compare the understated portraits of Betty and Stanford—pages 21 and 18, respectively—with the growling sky behind Samantha, page 17.) Zador's aesthetic catechism is nothing if not (small-c) catholic—and she's recently broadened her purview even further by painting a number of personalities from the pages of kitty history. (See the portraits of Missy, page 12; Isis, page 38; and Katrina, page 42.)

Yes, the katzenjammer of attention that surrounds Zador and her work is well deserved. Her paintings' surface richness—she works only in oils—is matched, admirers say, by the psychological depth her canvases consistently disclose. "She truly lets the cat out of the bag," says one happy client.

In Zador's fortunate case, quality has translated into status. These days, hep-cats and -kittens of every stripe are scratching at her studio door, demanding the chance to be immortalized by her brush. Eagerly anticipated, *The Well-Bred Cat* gives all of us, at long last, the chance to see for ourselves why she's catapulted from success to success.

ATTICUS

AS EVERYONE KNOWS, CATS LOVE MATH. Kittens begin mathematical training early, taking instruction from their mothers in the basic trigonometric principles involved in catching a mouse on the run or making it from the ground to the top of the garden fence in a single, parabolic bound. For most cats, though, arithmetical expertise is little more than play. It's the rare feline who strives to reach the heights of mathematical insight.

Such a number cruncher is the British domestic longhair Atticus, who made headlines a few years back by proving Fur-Mat's theorem. For Atticus—nicknamed "Abacus" by his friends—math's pleasures are subtle indeed. As a kitten, he loved to lie on the floor beneath a window, working out the algorithms to determine the precise number of minutes it would take a slowly shifting patch of sun to reach his resting place. During those hours of quiet cogitation, he'd barely move at all, and only the occasional ear flick registered that he was still alive.

His sisters thought him lazy, but his mother, herself a skilled mathematician, was quick to recognize his genius. On forays into the garden—while his sisters swatted wasps and nibbled on the decorative grasses—he would listen carefully as Mummy explained how the dahlias' petals illustrated the mysterious Fibonacci sequence. Already, there was little doubt concerning the magnificent trajectory his career would take.

Zador's study of Atticus, painted when he was a young tom at university, was commissioned by London's National Portrait Gallery. In it, she captures the youthful wizard's distracted gaze, as he pauses to contemplate the implications of an especially intractable passage in Russell's *Principia*.

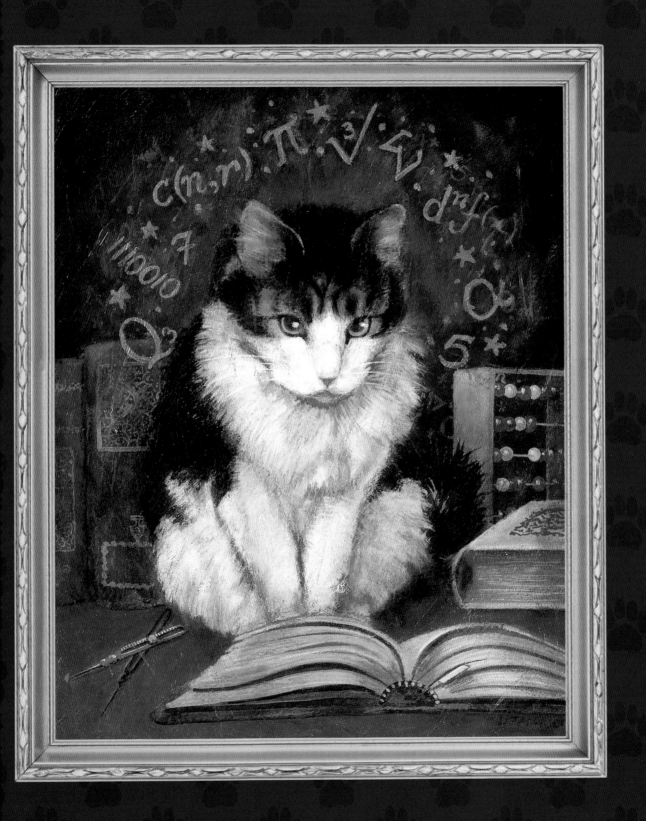

MISSY

Tops among Zador's feline heroines of the past is Missy, the undisputed queen of Manhattan's gossip mavens of the thirties. Long before Suzy and Liz, Missy was skewering ill-behaved celebs and lambasting politicos who strayed from the straight and narrow—as defined, of course, by Missy herself. With her 400 Club pedigree, this snowy Persian never forsook the impeccable manners—and deceptively demure social presence—that her upbringing had instilled. In person she purred; in print she roared—and moguls, movie stars, millionaires, and mobsters alike fell under her spell. She was their confessional—and her readers lapped it up.

Why did her victims, time and again, allow themselves to be led so placidly to slaughter? Several contemporaries reported that it was the disarming, mesmerizing quality of her gaze. "Missy's eyes were of different colors—one green, one yellow—and when she turned those Technicolor searchlights on you, you were hypnotized. You revealed all," recalled one pills- and booze-dependent screen goddess, years later, in her rueful autobiography.

Missy's success was phenomenal. Her column, "Le Chat," skyrocketed the circulation of *The Daily Dispatch* tabloid. Millions nationwide religiously tuned into her weekly radio broadcast, *The Scratching Post*—broadcast live from her Fifth Avenue apartment. She never shied away from a catfight, even with the highest and mightiest. She was, one commentator declared, the "Conscience of the Ruling Class." Her own assessment of her career was more modest: "I'm never just catty," she said.

It was, however, a lonely life. She had hundreds of intimates, but no real friends. By '37, she was sick of the social whirl—had even grown tired of rubbing too many people the wrong way. She retired to a Connecticut farmhouse. (Her memoir, *The Fur Flew,* did cause a brief stir when it was published, just after the war.) Zador's portrait—inspired by a number of period photographs—captures Missy during her glory days, dressed to the nines and ready for an evening's prowl through the down-and-dirty lairs of high society.

SIR MORTIMER

SIR MORTIMER POSSESSES LITTLE PATIENCE for the current generation of climbers. "Why, today, any Tom, Dick, or Jerry who manages to attain the summit of some minor Himalayan peak thinks he should write a best-seller about the hardships he's endured," he sputters. "Any puss-in-hiking-boots with sixty grand to throw away can jet to Katmandu for a risk-free scamper up Everest."

Things were different in his day. The gear was primitive, the yak-hide tents smelly and drafty, the maps—drawn ages ago by Lhasa Apso monks, and decorated with hideous dog-faced deities—intentionally deceptive. "Even the bloody weather was worse," he wheezes. Sir Mortimer knows whereof he speaks: his lungs damaged by a lifetime lived in the anemic mountain air, his left hind paw permanently numbed by the nasty case of frostbite he sustained on his seventh expedition.

His good looks, at least, remain intact, aided by his always impeccable grooming. Zador is in awe of him. All that outward bluster, she insists, is so much self-protection. "He makes himself out to be the Abominable Snowcat," she says, "but he's really a quivering little kitten inside."

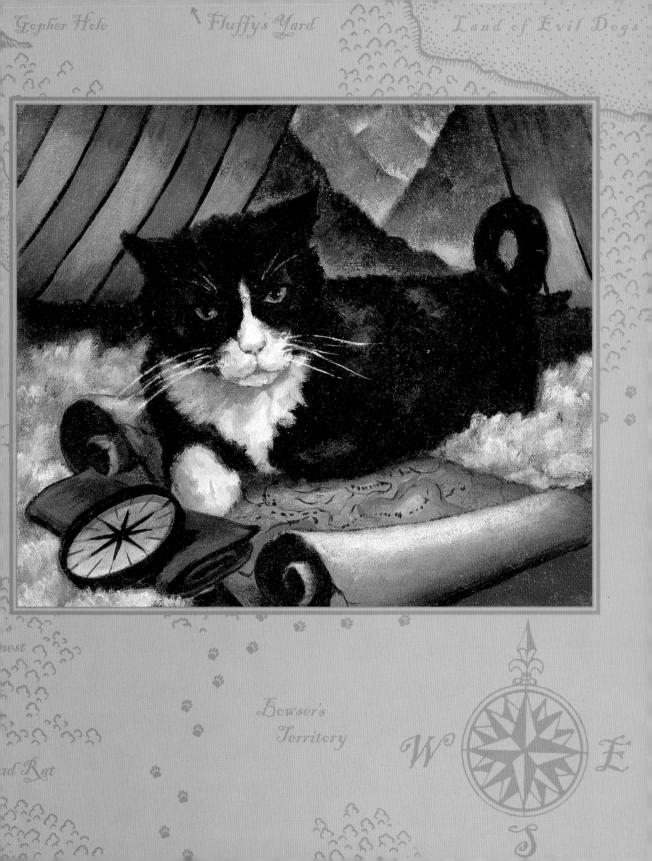

SAMANTHA

ER WIDE-SET, DEEP GREEN EYES AND KITTENISH POUT still send the same intriguingly mixed messages: penetrating yet coy, come-hither yet aloof. Yes, Samantha still exudes an air of erotic enchantment, exotic mystery. That is, if you don't let your glance fall below the neck. Let's face it: Our Sammie has a bit of a weight problem.

"Don't you agree that I've lost my appeal?" This, disarmingly, is the first question she puts to the visitor to her Sag Harbor cottage. It's a sad, embarrassing obsession for the once-irresistible *féline fatale*, whose exploits as a secret agent, it's said, fashioned the basis for the espionage classic *You Only Live Nine Times*. Her career was that of a bona fide Pussy Galore—scaling the Berlin Wall, slinking past missile-silo guardhouses, casting her lithe shadow on the walls of souks from Fez to Kandahar. Whether smuggling a microchip, distracting attention at an embassy ball, or clawing her way out of a dicey situation, it was her looks—the face *and* the figure—that got her through.

It's a much colder war she's now engaged in—this struggle against the betrayals of age and the double crosses of the flesh. And a much less exciting one: These days, the only moles she roots out are the ones in her bungalow's backyard.

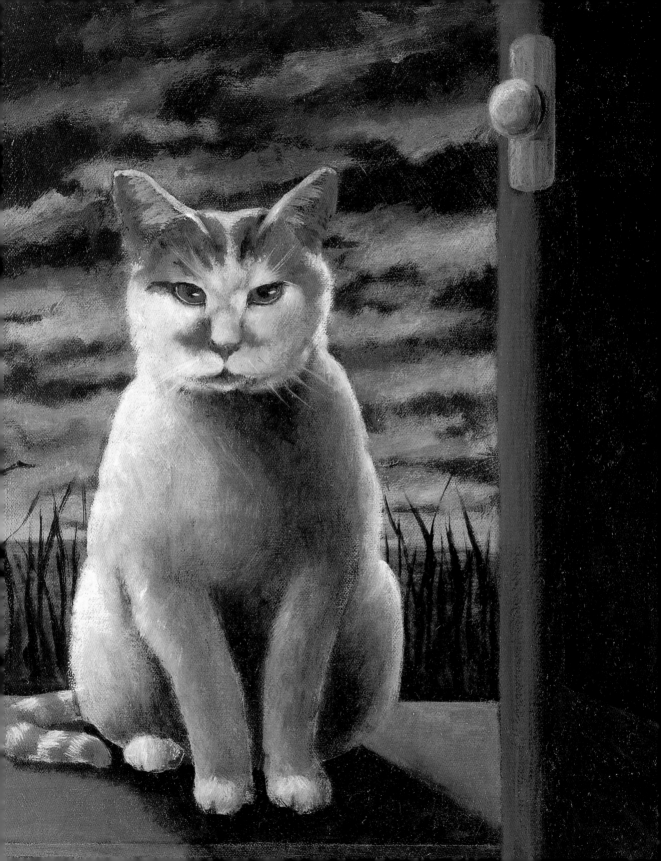

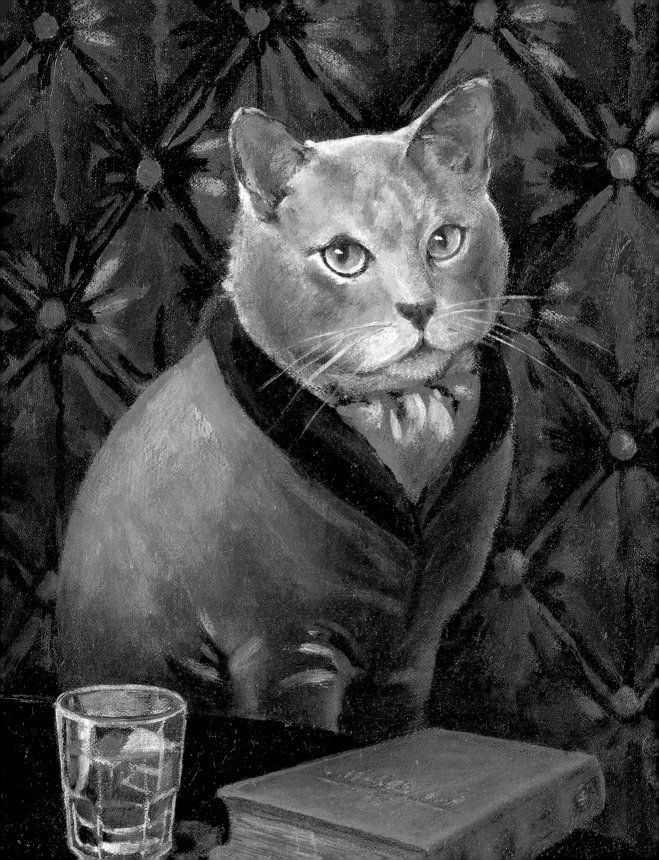

STANFORD

STANFORD'S BOURBON IS OLD DEUTERONOMY, aged 17 years. His cigars—on the rare occasions he permits himself the indulgence—are Havana Browns. His club, of course, is the St. Ives. And the book? Oh, it's just a little something he picked up—a leather-bound, eighteenth-century translation of Catullus. (He likes to pass the time rereading the naughty bits.)

Zador admits to being intimidated by the prospect of painting him. After all, he's the only one among her patrons who can boast a genealogy extending back to the *Mayflower.* (The name of his great-great-great-great-great-great-great-[et cetera]-grandfather appears in the ship's log as its official rat catcher.) To her delight, he wasn't at all stuffy—unlike the St. Ives's other members, whom Stanford winkingly describes as "virtually taxidermed." He is, in fact, a bit of a rake, and by the end of their first session his ribald tales and off-color jokes had her laughing so hard she could hardly hold her brush. "You see? There's still some life in this Old Tom," he told her—as he discreetly laid his paw upon her knee.

BETTY

EARTHA KITT, TAKE HEED: Betty's back! For her cabaret *rentrée* at Manhattan's Kitty Carlyle Café, the legendary chanteuse has strung together a selection of old favorites ("That Old Black Magic," "Mood Indigo," and "Black and Blue") along with a medley of Gato Barbieri and Cat Stevens tunes and her trademark show stopping finale, "Walk on the Wild Side." Naturally, she punctuates the whole shebang with devilish asides about virtually every celeb whose path she's ever crossed.

Betty's a true vet. Bad luck's pursued her—the accident, the miscarriage, the rotten romances, the stint in rehab—but she's always managed to land on her feet. She may get a little misty-eyed when she sings that she's "as helpless as a kitten up a tree," but her adulators know she's as tough as toenails. Never one to pussyfoot, she's sometimes gone out of her way to court controversy. Why, just a few years back she grabbed headlines by becoming the only Blackglama model ever to pose in the absolute nude (except for the never-leave-home-without-'em pearls, of course).

Zador herself is a dyed-in-the-fur fan. Her favorite number from Betty's repertoire? It's gotta be the Big B's caterwauling rendition of "The Manx I Love."

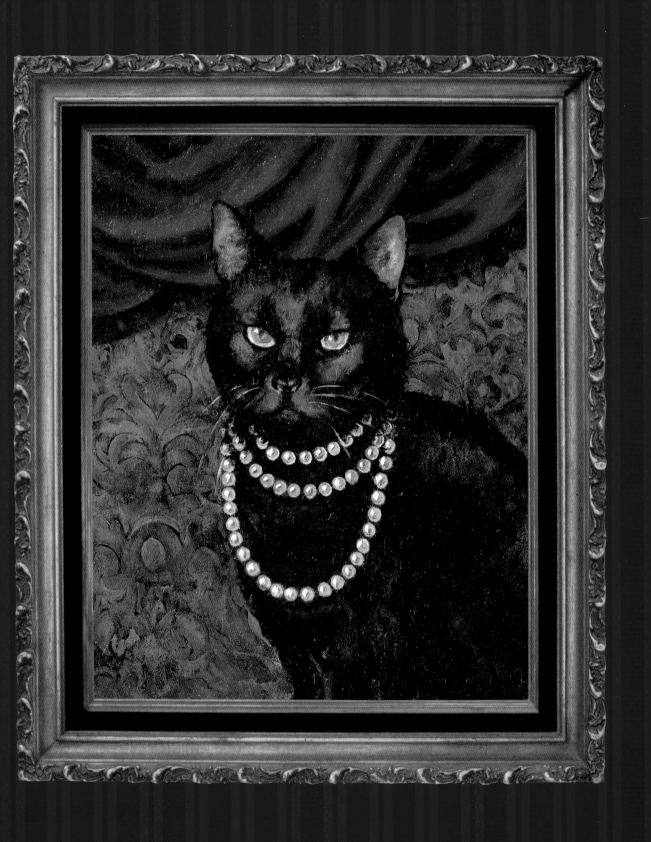

BARRY

ZADOR KNOWS THAT NOT ALL WELL-BRED CATS are creatures of leisure. Some must work—and work hard—just to put Whiskas in the food dish. For Barry, a wannabe Broadway star now playing the dayshift as a bellhop at midtown Manhattan's famed St. Felix Hotel, it's a depressing reality. When Barry hit Gotham a few years back—with nothing to his name save some half-decent summer stock notices and a couple of dog-eared headshots—he was convinced it wouldn't be long before he'd see his name in lights on the Great White Way. Opportunity abounded, or so it appeared: *The Lion King* had just opened to rave reviews; it seemed like *Cats* would never close; and *Cabaret* (set, of course, in the Kit-Kat Club) was playing to SRO audiences. Alas, 'twas not to be. So far, the only part he's landed was a walk-on in a children's theater production of *Dick Whittington*.

Barry admits to Zador that some days he works himself into a funk. "The tips aren't bad," he says, but he resents the condescending attitude of the St. Felix's fat-cat patrons. "They treat you like you're sub-feline," he whimpers. Zador tries to be encouraging. After all, it was Barry's matinee-idol looks that led her to ask him to sit for this portrait. She's convinced he'll go far—once he learns to sharpen his claws and does what he's got to do. "The casting room couch is not for catnapping," she reminds him. The gentle nagging seems to be working. These days, Barry spends his lunch break poring through the cattle-call ads in *Variety* and *Backstage*.

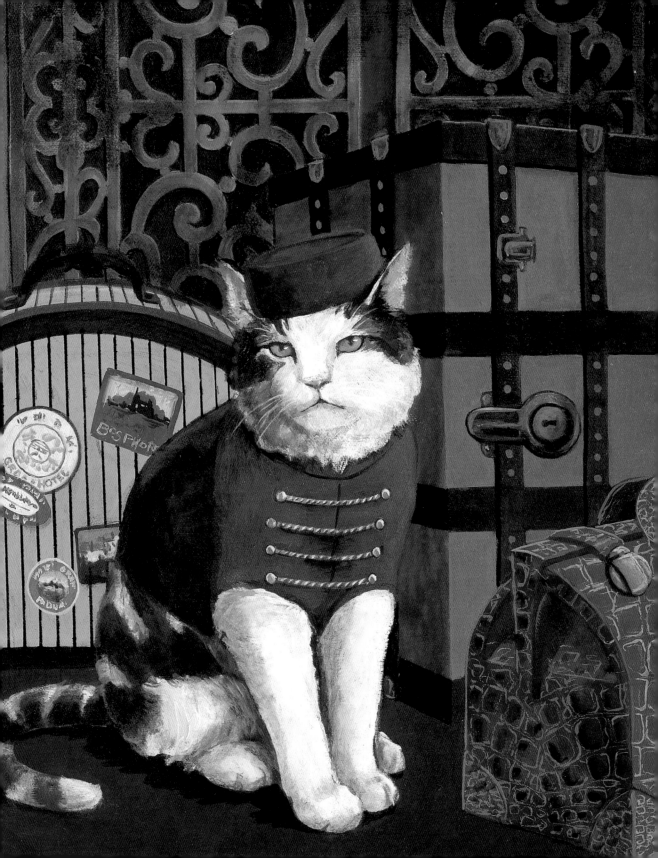

EFFIE

"THERE ARE THREE KEYS TO SUCCESS IN THIS WORLD," says clock-cat Effie, "and they are scheduling, scheduling, and scheduling. In that order." The celebrity time-and-cost analyst, who's instituted her time-keeping regimen at a dozen or more Fortune 500 companies, allows how she's still amazed at how many of her clients have serious problems with things like rousing themselves from slumber or apportioning the appropriate number of minutes to ordinary tasks like grooming. "And we're talking about some top-cat types here," she exclaims. "I mean, I've seen some CFOs—chief feline officers—who were wasting so much time licking their hindquarters that they regularly missed shareholders' meetings and important video-teleconferences. Or they stay up all night and then wonder why they're so lackluster during the day. It's just appalling."

Critics complain about her cat-o'-nine-tails methods, but she says it's her business to whip offenders into shape. She begins with the basics. "You'd be astonished," she says, "at the number of cats who don't know the difference between February and September. They couldn't care less whether it's Thursday morning or Saturday afternoon. Well, I soon have them marching to a different drummer. And they thank me for it."

So far, Effie's focused her efforts on individual ne'er-do-wells, but she claims her next project will be that of *herding* cats. "It just can't be as difficult as they say," she told Zador.

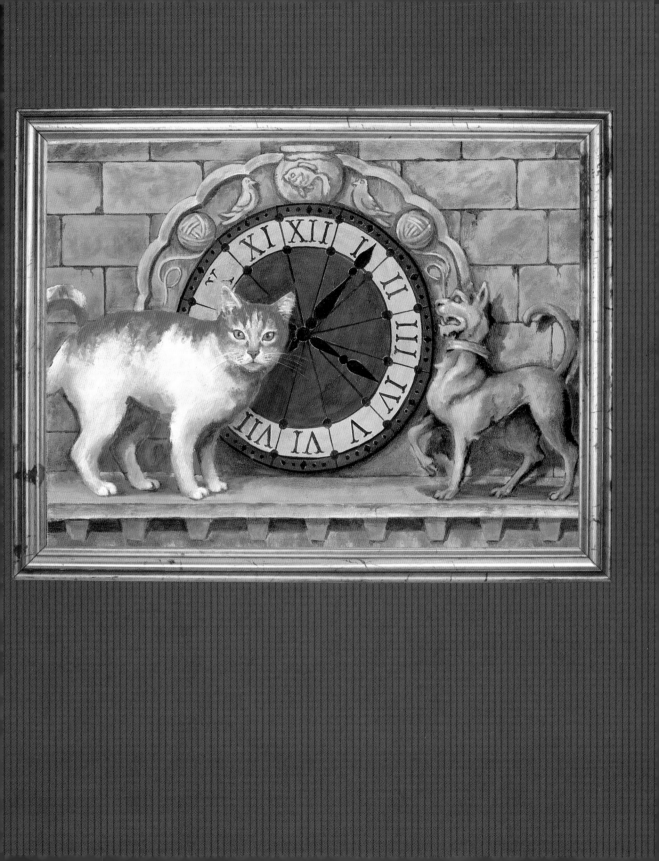

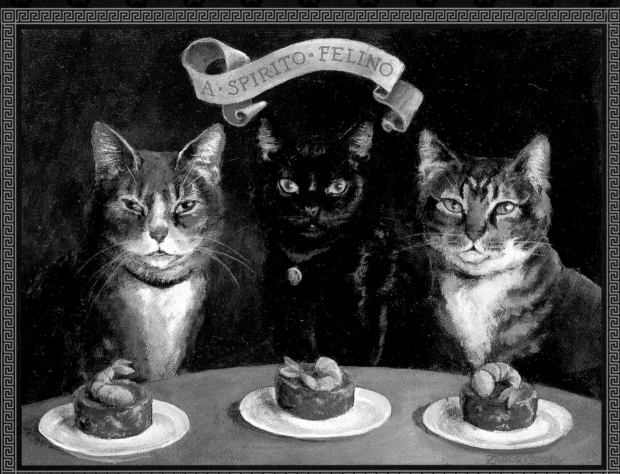

THE THREE

THEY MEET FOR LUNCH THE SECOND TUESDAY OF EVERY MONTH. The venue changes. Sometimes it's that understated trattoria on Carmine Street, sometimes a Georgetown tavern, sometimes one of those old-fashioned, starchy joints that one can still find tucked away in the back alleys of the Loop. They choose out-of-the-way places where the wait staff isn't snoopy. Their faces are vaguely familiar, but no one can quite place them. Some hint at a Sicilian connection; others whisper about O-Puss Dei.

Zador was aware of the rumors, of course. Still, the call came as a shock—a bit flattering (they'd heard of her!) and a bit terrifying. Would she be available on such-and-such a date? She should bring her paint box, and the portable easel. The flight—first class—was to San Francisco; she arrived at midday. The limo met her at the airport, took her to a Nob Hill bistro whose curtains were drawn. The restaurant had been emptied of all its other customers. They were already sitting at the table, waiting for her.

The session went smoothly, if rather stiffly. Only the black one—the one who always wears the medal—spoke. "Don't believe everything you hear," he said. "We're just three old fellows who like good food and one another's conversation." Zador detected the trace of an accent. He suggested she add the motto in the banner above their heads. "It's for posterity," he added cryptically.

When she'd finished, the canvas was taken from her. She was paid handsomely, in cash. That night, back in her studio, she repainted it from memory. *Vanity Fair* and the *Weekly World News* have begged her to allow them to publish it. She's declined the offers. You're seeing "The Three" for the first time.

SIMON

THEATER MAVENS KNOW SIMON as one of the sharpest-clawed, roughest-tongued critics around. The catalyst for many a show's failure or success, Simon has his likes (few) and his dislikes (quite a few). He loves *The Mousetrap* on principle, and there's a very soft spot in his very hard heart for a certain play by Tennessee Williams. About his dislikes he's hardly pusillanimous. He condemned one production of *Oedipuss Rex* as "blindingly awful." He literally hissed at the latest revival of that tired old musical *Hello, Kitty!* And it's been noted that he particularly loathes the works of a certain Lillian Hellcat; about her dramas—which include *The Litter Boxes* and *The Kittens' Hour*—he famously remarked that not one line of dialog rings true, not even "meow" or "mew."

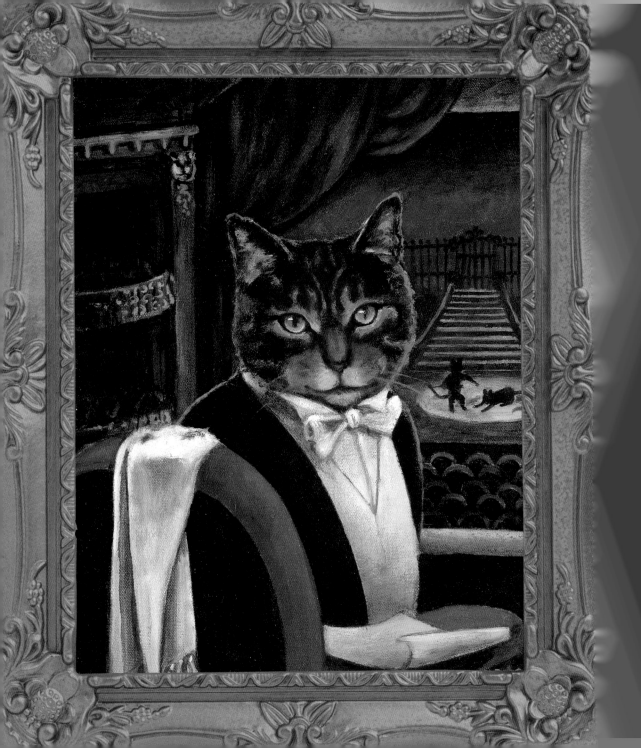

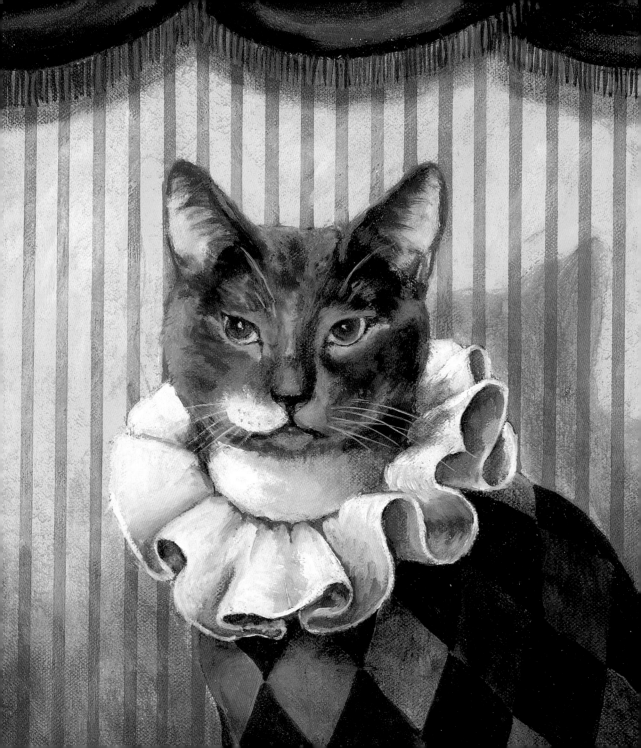

LULU

LULU DESPISES FANCY-DRESS BALLS—the bother, the competitiveness, the discomfort. ("I'm so hot and itchy in this silly getup that I could die," she says.) In fact, there isn't much about her obligations as a society doyenne that satisfies her. She *loathes* lunch. ("I just push the food around my bowl and wait for it to be over.") Charity functions bore her. ("I don't see why I can't just send a check.") The social climbers in the Hamptons and St. Bart's appall her. ("The Catskills are *so* much nicer.") Openings, galas, cocktail parties make her cataleptic, and publishing-world events—those book launches and poetry readings and Literary Lion dinners she's always being dragged to—are, to her mind, worst of all. ("The truth is, I like curling up and snoozing in front of the TV.")

You wouldn't know it to look at her. Lulu is always *so* correct. Even the harlequin costume she wears in this picture is modeled on the garb of a Blue Period Picasso *saltimbanque* that graces the parlor of her Murray Hill townhouse. ("I know I'm not supposed to say this," she admits, "but I prefer Andrew Wyeth.")

Even Zador was fooled. But it all came pouring out during the long afternoons when Lulu sat for her portrait. *That* sort of thing, of course, happens to Zador all the time: "They tell me things they don't tell anyone else—not their therapists, not their accountants, not their groomers," she says. Still, Lulu's confessions ("I abhor opera singers, ballet dancers, investment bankers, and antiques dealers!") amazed her.

"It's a terrible life she leads," says Zador, who isn't usually given to feeling sorry for her pampered clientele.

SERGE

T HE CHILDREN COMPLAIN THAT HE'S SQUANDERING THEIR INHERITANCE. Serge can't help himself. The missus threatens to divorce him should he bring *one more toy* into their already jam-packed den. But Serge can't help himself. He *must have* at least one example (preferably in unused condition, preferably still in the manufacturer's box) of *every* cat toy ever created. Not, mind you, toys *for* cats. It's toys *of* cats that he collects. And what a kit and caboodle he's accumulated.

Like any maniac in the grip of an obsession, Serge rationalizes his behavior. "I'm reclaiming my heritage," he says. His collection "ironically deconstructs the species-ist cultural assumptions that have permitted the objectification of the feline genus as plaything." Yeah, right. What's he's doing is spending tons of money on teddy cats, cat-in-the-boxes, rocking cats, tin-soldier cats, cat dolls, cat trolls, action-figure cats, Cabbage Patch Kits. What he's doing is rummaging through trash cans in hopes of finding a discarded wind-up cat or cat pull-toy. What he's doing (say the wife and kids) is *sick*.

Zador—who knows a thing or two about obsessions—disagrees. She says she's never seen anyone so happy, so content, as Serge among his toys.

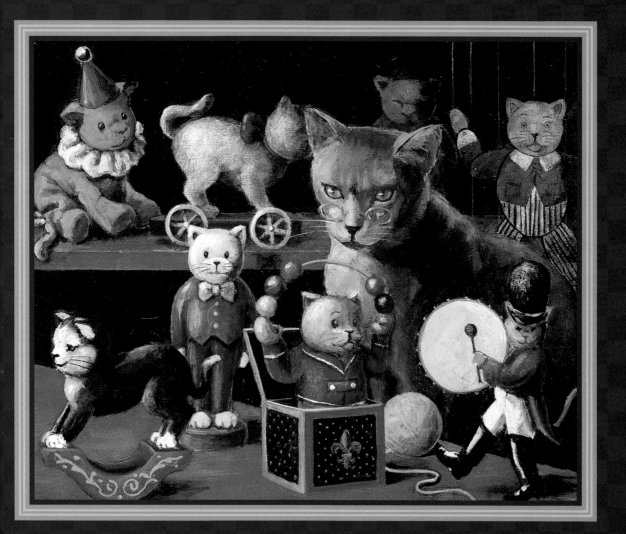

TRIXIE

NOT FOR THE NEUTERED, Trixie's late-night call-in show, *Venus with Fur,* has viewers throbbing—some with pleasure, some with fury. America's foremost sex kitten regularly draws yowls of protest from the prudish, who denounce her program as "the cathouse of the airwaves." Her devotees, however, credit Trix with reinvigorating their private lives.

Dispensing advice in a deep-throated purr, she's marked out a broadcast territory all her own. There's no topic too outrageous, no practice too esoteric—Himalayan tantra, Persian piercing, Abyssinian S&M—that Trixie won't address it frontally, so to speak. And because she's not shy about using the show to hawk her own "In Heat" line of intimate products, she's making a cat-mint. (Her patented ViaGrowl aphrodisiac is proving especially popular.)

With Zador at the easel, Trixie immediately doffed her kit. It fell to the artist to suggest—ever so gently—that a few well-placed pillows might make for a more tasteful portrait.

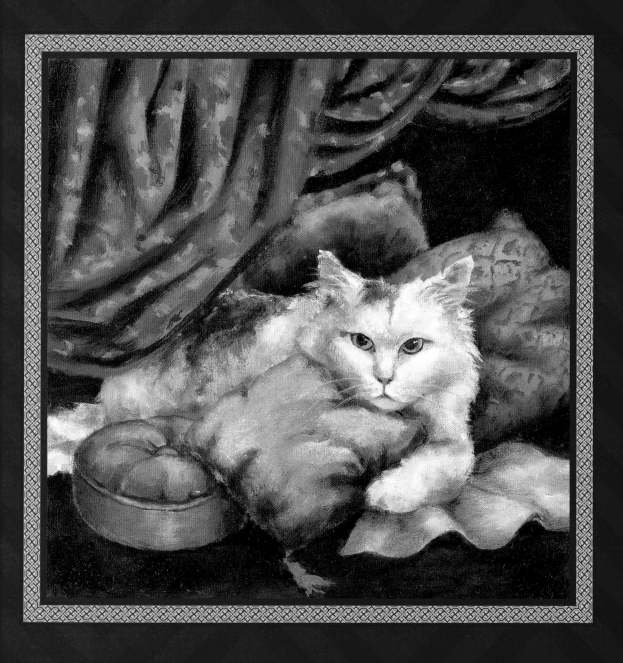

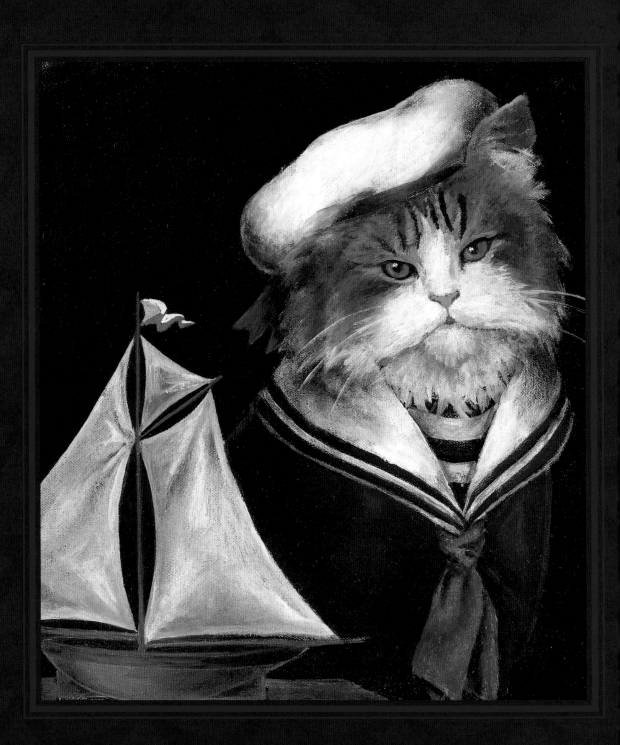

BABY

THINK CATS AND WATER DON'T MIX? You haven't met Baby—the gal who put the "gata" in "regatta." Baby's hydrophilic instincts and nautical skills were in evidence from the moment she left her cat's cradle. Her mother remembers, with undiminished wonder, how much little Baby loved to take a bath. Like all kittens, her brothers enjoyed unraveling balls of yarn—and getting themselves tangled up in the strands—but their sister's ability to transform a skein into a series of perfectly executed square knots, loops, and figure eights was uncanny, to say the least.

Growing up on the Cornish coast, she was always fascinated by the sea. By the time she was a year old, she was hitching rides around the harbor from the local fishermen. At two, she was captaining her own vessel, *The Kitty's Wake,* offering whale-watching cruises to dubious tourists. At four, she captured global attention with her first-ever one-cat trans-Atlantic sail.

It's hard to say what caused it—perhaps the weeks she'd spent alone, midocean, with no one to stroke her or scratch her chin—but, shortly after that daring voyage, Baby went off the deep end. She became convinced that felines had arrived in the New World by sailing eastward from Polynesia to South America, and she somehow scraped together the funding for what the media dubbed her "impossible journey." On a catamaran she christened the *Kon Kiti,* the intrepid puss set sail from Tahiti, destination Peru. A few days out, radio contact was lost; during the long silence that followed, the world waited breathlessly for word of her whereabouts.

Finally, a search-and-rescue mission was dispatched. Amazingly, the helicopters located her—the weather-battered catamaran drifting aimlessly in the vast horse latitudes. She'd been going in circles for weeks—"Just chasing my own tail," as she later told the press.

She vows she'll try again. "The only thing that really frightens me," she admitted to Zador, "is that—believe it or not—I've never learned to swim."

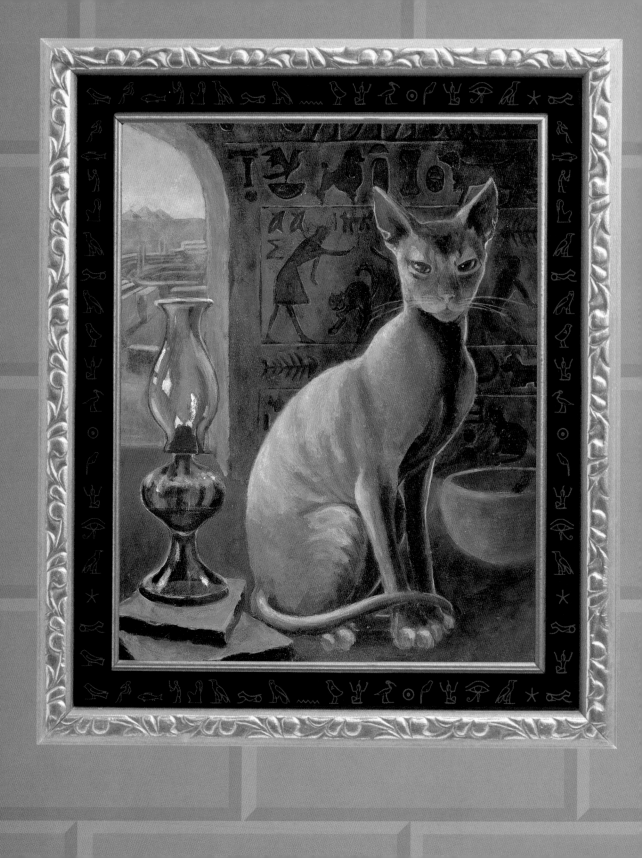

ISIS

Isis was a riddle. She was, she famously claimed, the reincarnation of the high priestess of her goddess namesake. She insisted she'd arrived in Massachusetts direct from Thebes, circa 1800 B.C.

For decades, Boston had endured an onslaught of charlatan clairvoyants, suspect soothsayers, and all manner of miscreant mystics, but Isis belonged to an altogether different breed. Historians of the paranormal—even the most skeptical and level-headed—still don't know what to make of her.

Her appearance appalled the brahmins of Beacon Hill, but for a couple of years during the nineties there wasn't a Back Bay hostess who wasn't desperate to titillate—and terrify—her guests with an Isis séance. She was as big a hit with the lecture-going set at the Athenæum as with the roués of Newbury Street salons.

Mary Baker Eddy condemned her; William James interviewed her; Isabella Gardner briefly took her up. The straitlaced editors of *The Globe* excoriated her "fanatical and farcical" devotees. The Director of Antiquities at the Museum of Fine Arts, outraged at the "credulity" of his fellow citizens, decided he would call her bluff. He proposed an examination, and Isis consented.

On a chilly, moonlit evening in November 1893, a standing-room-only crowd gathered in the auditorium of the Public Library. Isis appeared on the podium, followed by the Director, who'd carried along a sheaf of New Kingdom papyri. He presented her with one of the fragile scrolls, commanding her to translate its hieroglyphs. She did. Scoffing at what he was convinced was a stage trick, he gave her another. Again, she read the text—her translation differing only insignificantly from that in the notebook that the Director held in his now-trembling hand. A third papyrus was unrolled on her lectern—with the same result. The audience went wild. The Director, accompanied by catcalls, fled, resigning his post the very next morning.

Zador loves that story.

HARLAN

H E WRITES THE KIND OF NOVELS—grisly, maudlin horror-thrillers—that drive literary types up a tree. His numberless fans don't bother reading the reviews. Harlan's first book, *Swing a Dead Cat,* climbed to the top of the best-seller list and sat there—grinning at the critics—for months. His second, *To Skin a Cat,* stayed for nearly two years. His third, a collection of short stories entitled, simply, *Tails,* broke all sales records for the genre. It's expected an entire forest will be felled for the first print-run of Harlan's forthcoming creep-fest, *Curiosity Kills.*

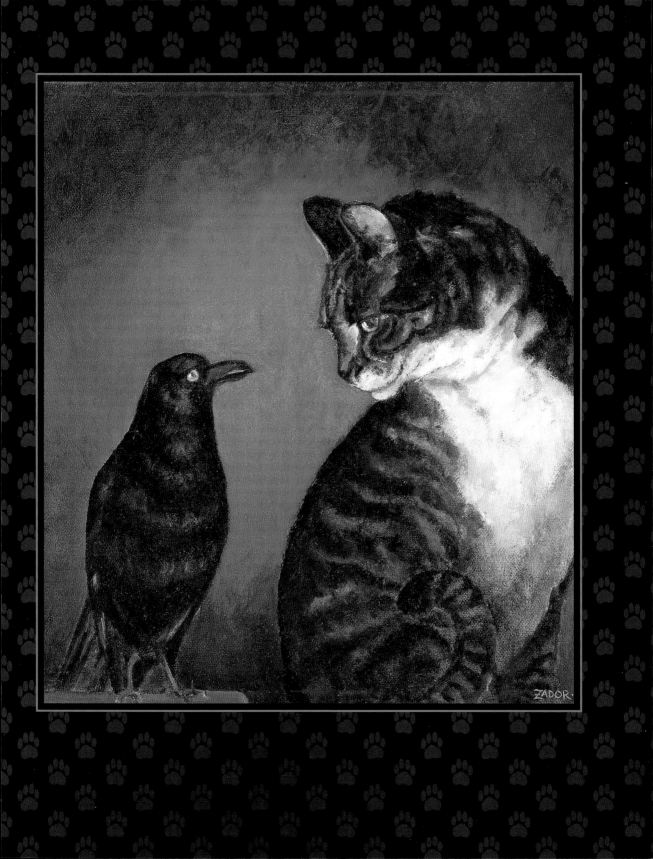

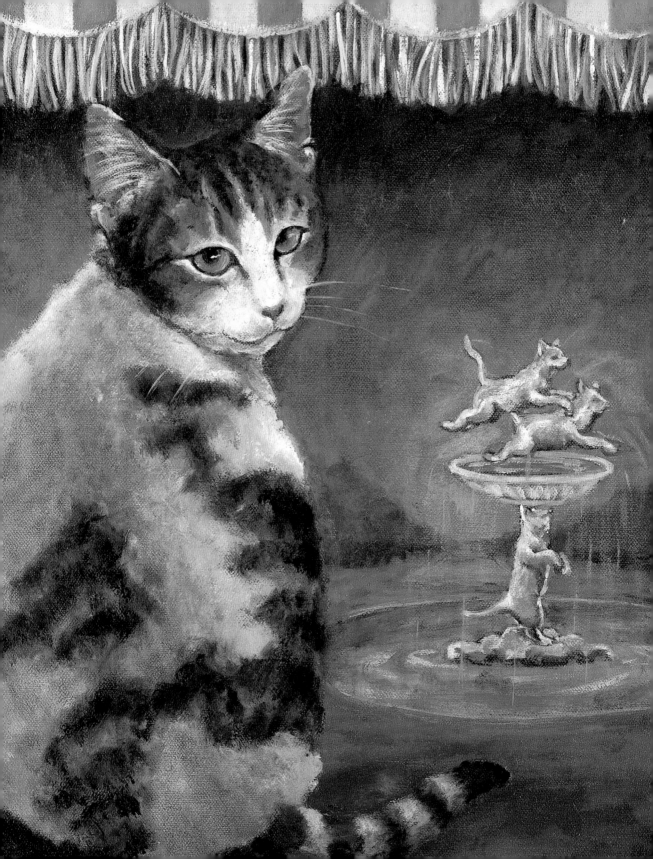

KATRINA

SADLY NEGLECTED AMONG THE GREAT EMIGRÉ POETS of the twentieth century is Katrina Pusskinova, whose calico political sympathies—she was neither a White Russian, nor a Red, nor a Blue—forced her into exile in Paris as Lenin tightened the leash on the Soviet avant-garde during the early twenties. Though largely unread today, her mewling versifications are ranked by a few discerning critics as equal to the poetic productions of the redoubtable Akhmatova and Tsvetaeva.

Katrina's distinctive whine can be discerned (even in clumsy translation) in fragments like this, from her epic-lyric "Exile":

Bitter exile!—
An endless morning during which I wait—
in hunger and futility—
for my food-dish to be filled.

And Katrina's trademark melancholic mood turns purely colic in lines like the following, from her lyric-epic "Nostalgia":

Bitter nostalgia!—
You are like a hairball, caught in my throat,
forbidding me from purring.

Her new home never suited poor Katrina. She seldom attended the social gatherings that livened the existence of her fellow emigrés. She refused to engage in the vain political plotting that helped other banished Russians occupy their time. Most days, she could be found sitting in an obscure corner of the Tuileries, near the delicate Fontaine des Chatons Sautants (Fountain of the Leaping Kittens), which was the inspiration for her most famous verse, the pastoral "Innocence":

Bitter innocence!—
Young kittens at play—
you know not that you leapfrog
into oblivion . . .

THE COPYCAT

THE PAPERS CALL HIM THE COPYCAT. Just who he is is a matter of some dispute. Scotland Yard claims he's Belgian. French investigators insist he's British—a Cheshire-bred, Royal Academy–trained *médiocrité*. The FBI, meanwhile, puts forward a theory of Middle Eastern origins—Qatar, or possibly Muscat. They're all desperate to snare him, but he's proven a very artful dodger indeed.

He's hardly a hack. In fact, he's the cleverest forger who's ever plied that disreputable yet glamorous trade. His all-but-flawless productions—in a concatenation of styles ranging from the Northern Renaissance to the Ashcan School—have duped auction-house experts, misled museum curators, ruined art historians' reputations, and frayed the nerves of compilers of catalogues raisonnés. His misattributed masterpieces grace the homes of unwary connoisseurs from Chatham to Chattanooga. He is, in short, a genius.

Zador has met him. She's talked to him. She knows the authorities have got him all wrong, but this cat has her tongue. She admires his skill too much ever to betray him. Sometimes, she even finds herself wishing she could *be* him.

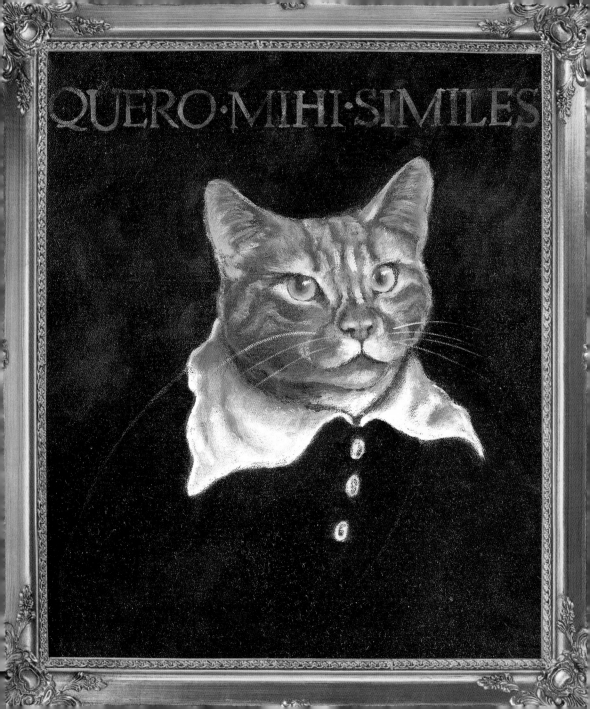

CAT-SITTERS

"Atticus" is actually Priscilla, the childhood cat of the artist's cousin Darren O'Dell, a Manhattan makeup artist.

"Missy" is modeled on the dear departed Contessa, who shared her life with architects Eric Hilton and Sik Lam, residents of Brooklyn.

"Sir Mortimer" is Dexter, who was photographed by the artist at the New York Humane Society.

"Samantha" is Louis, who used to be found prowling around Cherry Grove, Fire Island, every summer. The artist managed to snap a few photos of him before he disappeared.

"Stanford," whose real name is X-Ray, has enjoyed many happy years with his two sisters, Pya and The Goblin, in the home of Manhattan-based graphic designer Eric Mueller and costume designer Ramona Ponce.

Betty, who appears as herself, makes her home in Cherry Hill, New Jersey, with Keith Rosell, a lifelong friend of the artist.

"Barry" is portrayed by Spatula, who lives in Manhattan with Chris Anderssen, himself a working actor.

"Effie" is Phoebe, who holds the heart of print production director Kim Tyner, who believes that editors are no more efficient than most cats.

"The Three," in real life, are the decidedly non-sinister trio of Timmy, Felice, and Hector. They make their happy home with Jean Jerome and Theresa Yodice, on Long Island.

"Simon" is Cassandra, who was living at the Humane Society when she was photographed by the artist.

Lulu, appearing under her actual name, is the companion of editor Marisa Bulzone, who reports that the real-life Lulu isn't at all depressed.

"Serge" is Frank, the companion of Gene Bartow, who owns a Long Island insurance company and is astonished at how quickly cats take on the traits of their humans.

"Trixie" is Emily, photographed at the Humane Society by the artist.

"Baby" is Flike, editor Beth Huseman's feline friend, who apparently doesn't mind a short dip in the bath.

"Isis" is Zaboo, who lives with Paula and Don Spaight in New Jersey.

"Harlan" is Bowser, who, after losing a leg, was forced to retire from his position as chief mouser at the Brooklyn diner Jay's Kitchen. He now makes his home with waitress Rita Hashslinger and is resigned, at best, to sharing living quarters with a rather self-centered female tabby called Banjee Girl.

"Katrina" is Chelsea, who was living at the Humane Society when the artist met her.

"The Copycat" is Marty, another Humane Society resident.

LISA ZADOR, a native of Philadelphia, received her BFA from the Philadelphia College of Art. A textile designer and illustrator, she has worked for numerous top clothing designers, and her illustrations have appeared in *Harper's* and other magazines. In 2001, Stewart, Tabori & Chang published boxed sets of her "Swingers" and "Babalu" cards. She lives in New York City with her companions, Toby and Bingo.

JAMES WALLER is a writer and editor who lives in Brooklyn, New York. He is the editor of the *National Writers Union Freelance Writers Guide* (F&W Publications, 2000) and the writer of the *Moviegoer's Journal* (Stewart, Tabori & Chang, 2001). He teaches writing at Brooklyn's Polytechnic University.